D0122105

# The Tiny Book of Tiny Stories

1      2    volume   3

!t books

an imprint of harpercollinspublishers

Printed in China.

HarperCollins books may be purchased for educational, business, or sales promotional
use. For information please write: Special Markets Department, HarperCollins
Publishers, 10 East 53rd Street, New York, NY 10022.

FIRST EDITION

ISBN 978-0-06-212165-3

13  14  15  16  17  PH  10  9  8  7  6  5  4  3  2  1

# tiny stories

# 3

"The universe is not made of atoms;
it's made of tiny stories."

-Muriel Rukeyser  & wirrow

Are we recording?

Now wirrow, you say the universe is not made of atoms; it's made of tiny stories. So my question to you is, what are tiny stories made of?

But what are words made of?

Yes, and what are letters made of?

Ohhh...

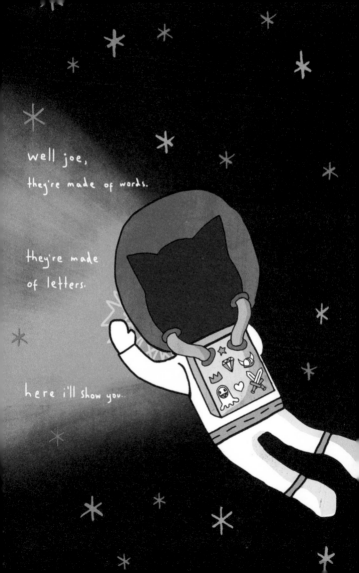

After a hard day's
make-believe I like to just kick
back with my creations.

You

promised

you'd

never

let

go...

This overwhelming desire
to be close to you

directly conflicts with my
intense fear of people.

When it's cold and night falls,
the mice run through the walls,

and the sleepy house groans
as it cracks its old bones.

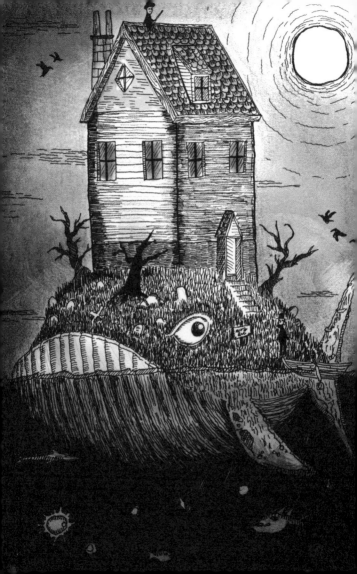

I have become their leader
even though I have no
idea what I am doing.

But they trust me and I love them.

Darrell never really
trusted Delbert.

There was just
something about him.

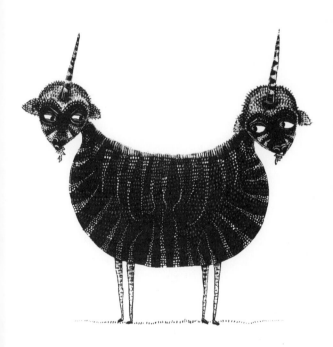

EXCUSE ME

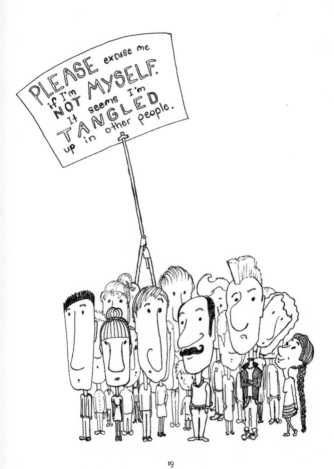

There were memories
in that melody.

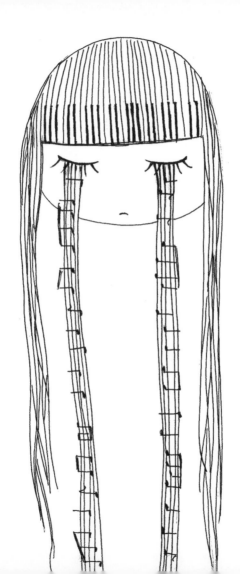

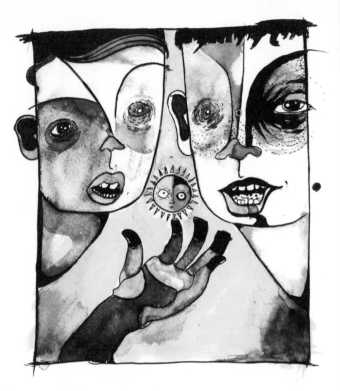

"It's beautiful," said the boy.

"Yes," replied the girl.
"Let's kill it."

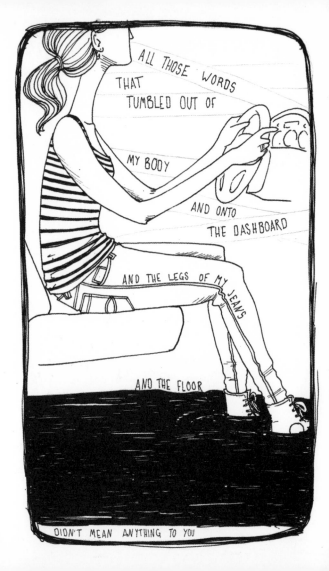

Her father's father told her dad,

and he again told her:

"Take care of your little treasures."

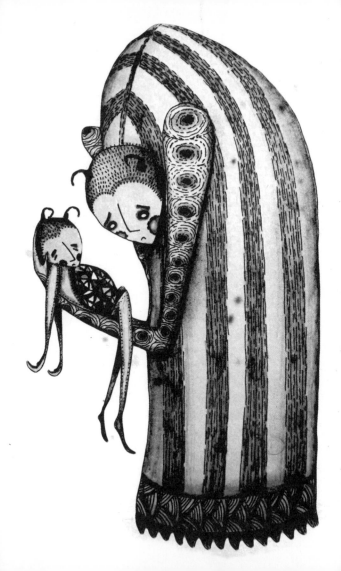

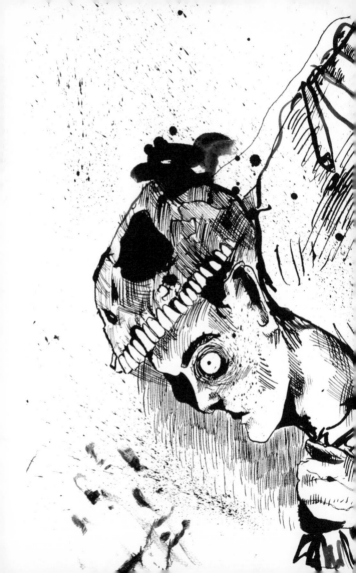

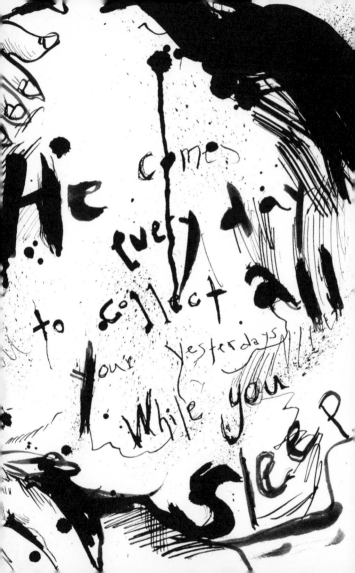

She's crying again.

But you should see what
happens when she smiles.

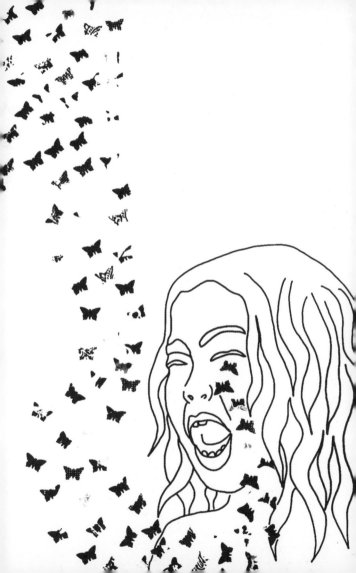

The fork spooned the knife,

so the spoon knifed the fork.

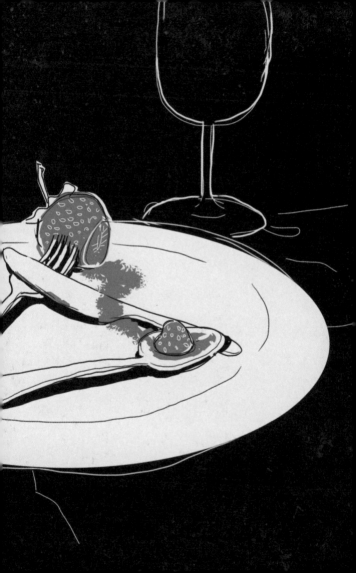

Disappointed,
the caterpillar assumed he was
building his own coffin.

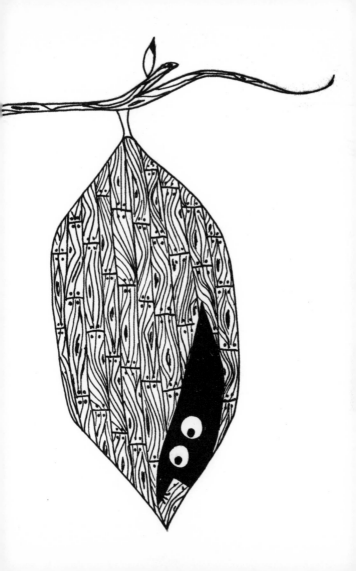

34

Stranger than strangers

are lovers estranged.

From my ship, adrift, I spied you.
And I thought you were an island.

Alas, you were an iceberg.

SNUGGLING

Ok let's snuggle for the whole day and then maybe two more whole days but then we'll get up and do some work! and we'll just take snuggle breaks in between to reward ourselves

I've already made
13 mistakes today ... no,
wait, I guess it was only 12.
So, yeah, 13 now.

They feel like precious gifts—
the secrets you share with me.

Even the disturbing ones.

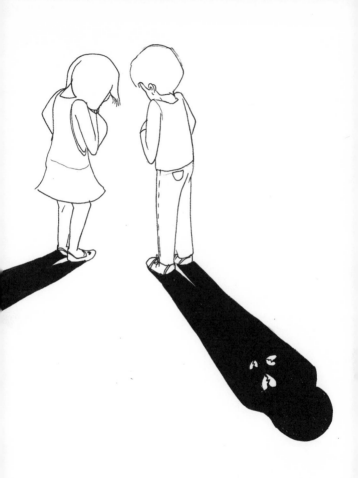

The flowers you bought
came to our house instead.

If I had a nickel for every
time I had a nickel and threw
it away because it was only a
nickel, I'd have thrown away
twice as many nickels.*

*Actually, this would result in an infinite number of nickels, as your nickels' nickels would also result
in nickels of their own, and so forth. Please don't do this. You'd be throwing away a fortune.

The poets pinned tragedies
to their chests like ribbons.

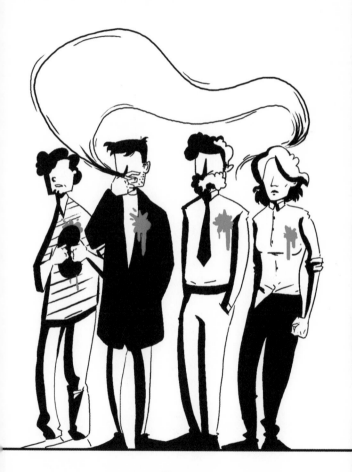

We used to perform
magic together,

before the incident.

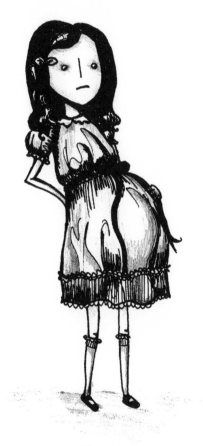

A HAIKU ABOUT
WAKING UP EARLY

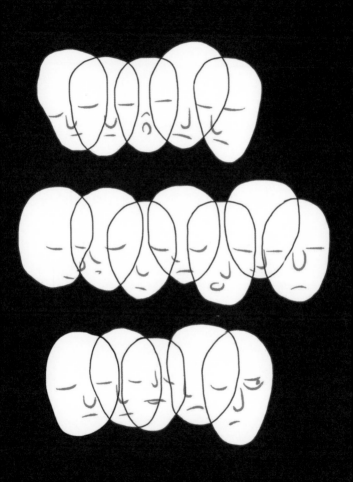

They stood on tiptoes
to glimpse the sky
whenever the great beast yawned.

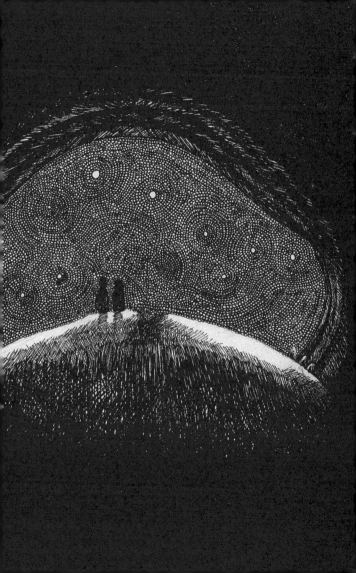

She rummaged through her future
to find what she was looking for.

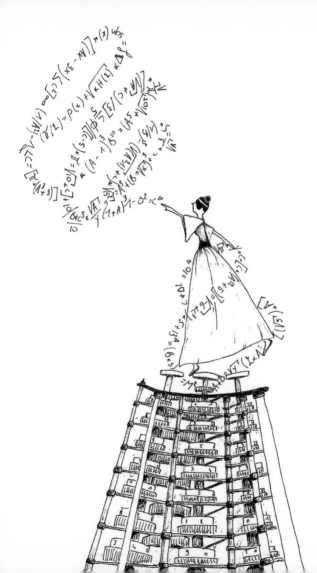

Pleasantries,
mathematically arranged,
are dogmatically exchanged.

we have captured the stars... the ni

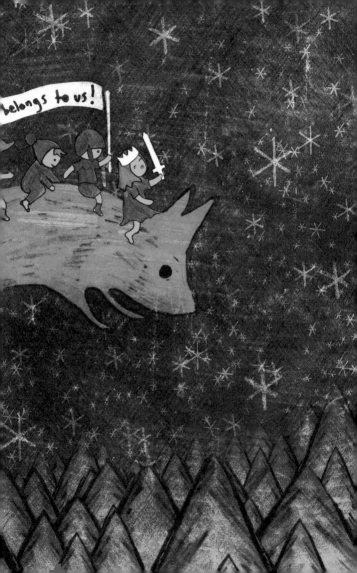

I want desperately to press
you between the pages of a
book and keep you forever.

When the lights came on
everybody just stood there,
silent and confused.

her socks are
amazing...

ugh... my socks
are so boring.

The giant bent down and
spoke softly to the girl.

"If this is but your dream,
little one, then please
sleep a while longer.

There is so much more
I wish to see."

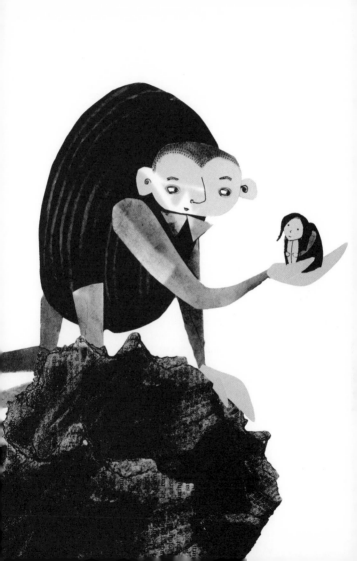

We could have been
the greatest love
story ever told.

If only you'd stayed
in character.

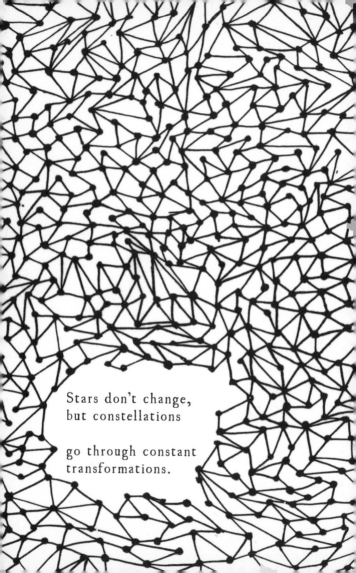

Stars don't change,
but constellations

go through constant
transformations.

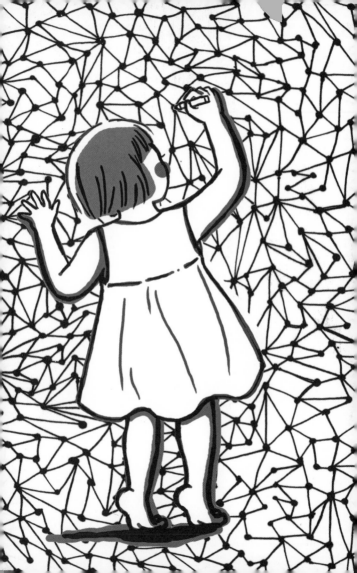

Every time I smile
it comes out as a frown.

I'm afraid my muscles
don't know up from down.

"Just a bad hair day filled with great things," she shrugged.

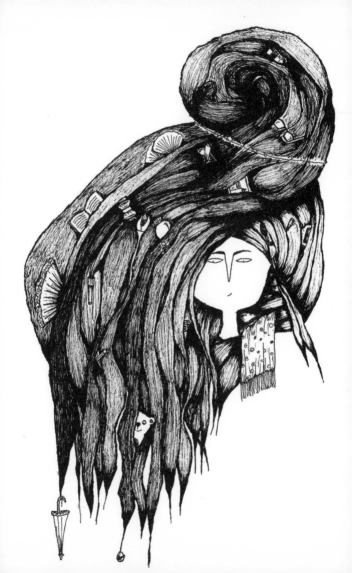

She scratched and scratched
until everything matched.

And then she scratched some more.

we wear
similar
hats

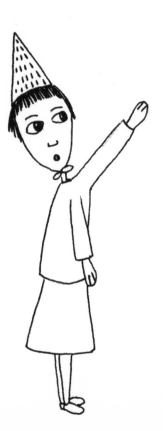

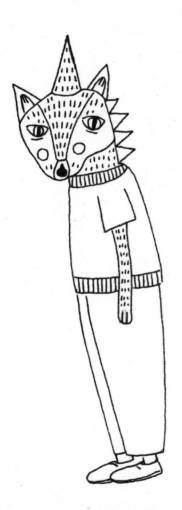

mine is
not a
hat

Back home, Eric is a national hero.
The crowds cheer his name.

But sound doesn't travel in space.

Frank was frying bigger fish—
claimed he had no time for nippers:

"Salmon is a finer dish."
Yet, oft, he longed for kippers.

She had a great big heart
but very little grace.

Every time she fell in love
she landed on her face.

"Today I will fly," said the
penguin. And he did.

Seems to me the less she knows,
the louder she knows it.

Somewhere in this vast
universe, there grows a boy.

And somewhere in this boy,
there grows a vast universe.

The mountain longed to
feel the saltiness of the sea.

A place he gazed on
but could never be.

"We're not friends anymore.

Sorry I always made you wear
the sidekick costume."

Blessed are they that crumble;

from them new worlds are made.

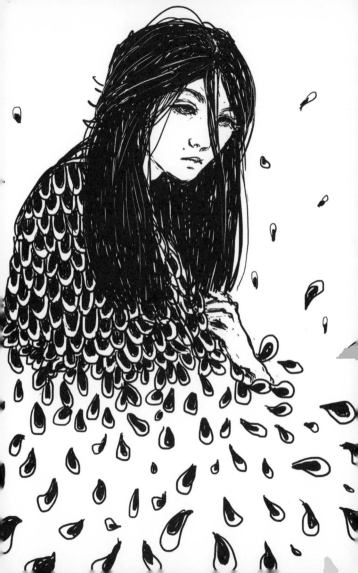

Anywhere

u

t

h    e

r    e    .  .  .

Let's call our confusion and
panic "self-preservation."

It has a better mouth feel.

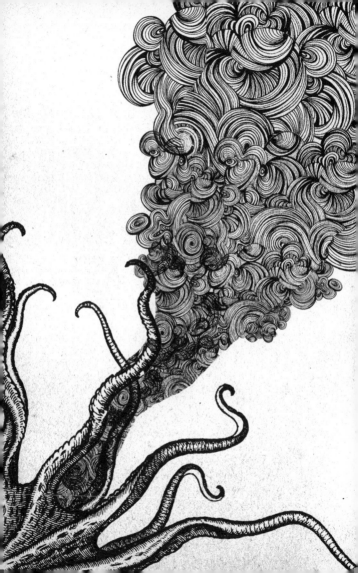

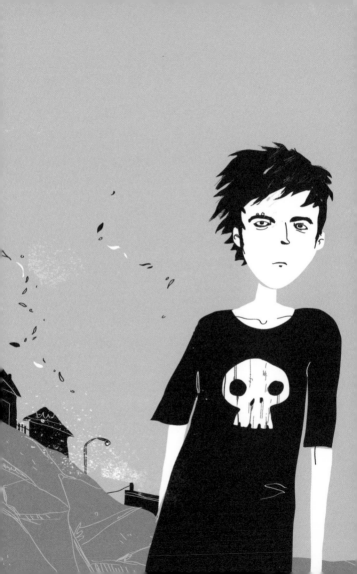

I was a small boy
in a smaller town,
growing up in a neighborhood
with no neighbors.

"Face it," he said.
"We are not brave men."

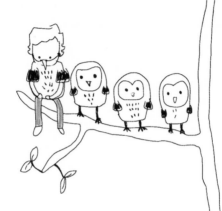

We are all gormless hosts

to homeless ghosts

that nestle in our most forgotten places.

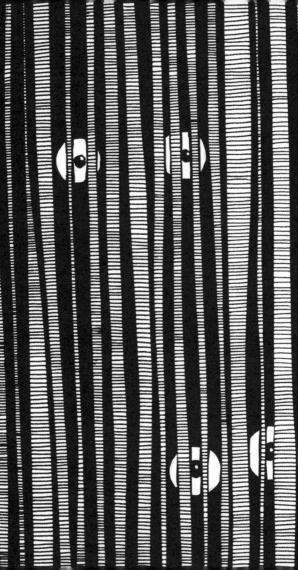

When I die,
let the dragonflies take me.

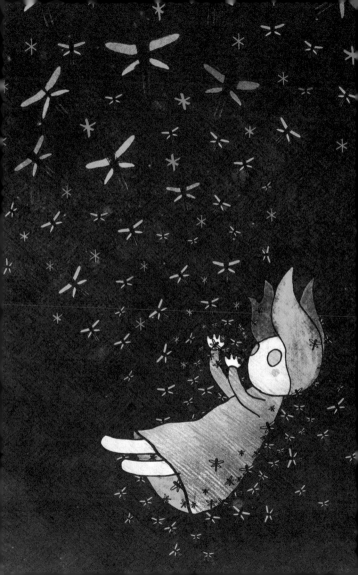

She drank in all their compliments
and soon she was full of herself.

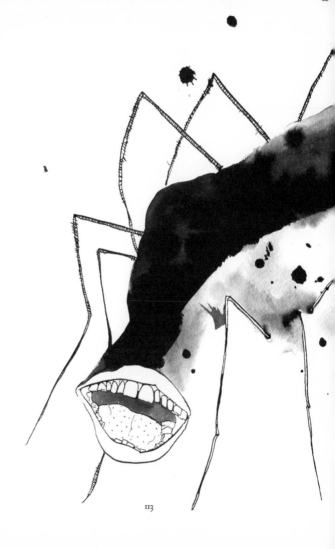

Monuments make momentous
men immortal, but more
memorable are mortal men making
mere moments monumental.

I am thinking of donating
my body to science fiction.

The angel of death
embraced him gently as he
broke free from the demon
of life's clenching claws.

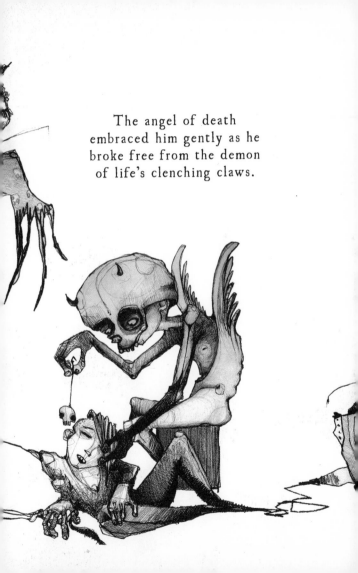

It doesn't matter how
many traps I set for them.
They keep multiplying.

Everything has a beginning,

even the end.

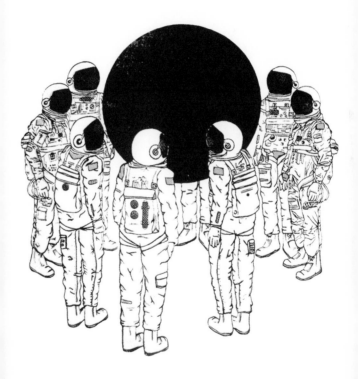

RESOURCES

| p. | contributor | record no. |
|----|-------------|------------|

www.hitrecord.org/records/record no.

| p. | contributor | record no. |
|----|-------------|------------|
| 04-05 | RegularJOE, wirrow | |
| 06-07 | wirrow | 1040289 |
| 08-09 | Metaphorest, imogenc, jessicaLEE | 1301224, 849299, 364742 |
| 10-11 | thedustdancestoo | 694661 |
| 12-13 | tori, RegularJOE, rabbleboy | 976153, 1303685, 1284601 |
| 14-15 | LadyJ, Marke, Jazminny | 1078249, 1341848, 1046025 |
| 16-17 | sojushots | 1231398 |
| 18-19 | mixedtapes, jay-9 | 999115, 1001132 |
| 20-21 | friendtrails, Marke urbanation | 1321191, 1331076, 926436 |
| 22 | Kubi, tdolan | 1084205, 1295271 |
| 23 | HowlAshby, cacheth | 1057603, 1067675 |
| 24-25 | sojushots | 1299625 |
| 26-27 | lizzybee, tdolan | 1103463, 1280966 |
| 28-29 | RosellaWeigand, Marke JenniferChittenden, tori | 1331088, 1341862 1283369, 1339613 |
| 30-31 | Joab Nevo, Dotunfolded | 766144, 1304173 |
| 32-33 | Kallee, Marke | 1295286, 1319119 |
| 34-35 | Zucherman, tori | 1291915, 1307250 |
| 36-37 | Metaphorest, daniellafers | 1105422, 1299739 |
| 38-39 | wirrow | 1159720 |
| 40-41 | Marke, aimi | 873211, 859102 |
| 42-43 | wirrow, Readmooses | 784149, 1089441 |
| 44-45 | BordeauxBlossom, cacheth | 1320108, 1297607 |

| p. | contributor | record no. |
|----|-------------|-----------|

| p. | contributor | record no. |
|----|-------------|-----------|
| 46-47 | Zucherman, ozie (disclaimer remark) | 1291508, |
|  | towhatextent | 1240855 |
| 48-49 | amcalledchief, Maliboo | 1087120, 1116277 |
|  | paperlilies | 1338692 |
| 50-51 | Kubi, Michal | 1065751, 1083318 |
| 52-53 | ex99, Dotunfolded | 1279351, 1303895, |
|  | paperlilies | 1338781 |
| 54-55 | Metaphorest, Marke | 1306286, 1341894, |
|  | imogenc | 1306844 |
| 56-57 | MattConley, Inger | 1293801, 982453 |
| 58-59 | wirrow, sojushots | 1312915, 1312751 |
| 60-61 | wirrow | 1310897 |
| 62-63 | littledot, thedustdancestoo | 1017029, 1001437 |
| 64-65 | Joab Nevo, Dotunfolded | 1279730, 1309216 |
| 66-67 | wirrow, Krstn | 1104749, 1192910 |
| 68-69 | Mcgettigan, sojushots | 1281562, 1282962 |
| 70-71 | TaschaS, mirtle | 1318435, 542609 |
| 72-73 | anna nimiti, wirrow, | 1278212, 1308817, |
|  | haley.aronow | 1323480 |
| 74-75 | SmudgeofPaint, JacksonBlack | 842138, 247023 |
| 76-77 | KendelleLyn, Inger | 1112285, 1104798 |
| 78-79 | TaschaS, RegularJOE | 1103480, 1304096, |
|  | AeB, CaptClare | 1312589, 1079798 |
| 80-81 | mirtle | 818890 |
| 82-83 | Metaphorest, pinstripesuit | 1301274, 1240836 |
| 84-85 | Metaphorest, Squibler | 1145138, 1320034 |
| 86-87 | anna nimiti, Jivincent | 1289307, 1317355 |

| p. | contributor | record no. |
|---|---|---|

www.hitrecord.org/records/record no.

| p. | contributor | record no. |
|---|---|---|
| 88-89 | saintmaker, AMountToEverything | 1271818, 1304160 |
| 90-91 | Helen Wrecoon, MummaSays | 1187697, 1272684 |
| 92-93 | Joab Nevo, RegularJOE | 1110662, 1304104, |
| | Kubi | 1309262 |
| 94-95 | ErinWelch, Marke | 1319804, 1341943, |
| | Kubi | 1225275 |
| 96-97 | joellen, Inger | 1130253, 1179681 |
| 98-99 | greenwillow77, dt.nguyen | 1320173, 998352 |
| 100-101 | sojushots, BordeauxBlossom | 812945, 1302593 |
| 102-103 | therayeraye, TheSerpentTheCharmer | 1304754, 1079431, |
| | PaperSquid | 862656 |
| 104-105 | rewfoe, Marke | 1285445, 1331389 |
| 106-107 | fdinamite, valeob | 1053579, 1160798 |
| 108-109 | oksanabo, Tanja Kosta | 941403, 1309520, |
| | wirrow | 1309352 |
| 110-111 | InkedCanvas, wirrow | 1063353, 1308826 |
| 112-113 | Kalymi, tdolan | 1092570, 1280961 |
| 114-115 | IAmRobynNicole, RegularJOE | 1293295, 1303694, |
| | Squibler | 1315608 |
| 116-117 | Murker, lola de toro | 1290056, 1081953, |
| | ceceliagavigan | 1313546 |
| 118-119 | pencil.just.dance., Joab Nevo | 1321153, 1021550 |
| 120-121 | CaptClare, Marke | 1148417, 1341986, |
| | LineDreamer, tdolan | 736373, 1077835, |
| | sophierumi, MiroKim | 812049, 1050506 |
| 122-123 | thedustdancestoo, Grandmasmethlab | 1319712, 1278828 |
| ends | haley.aronow, wirrow, Marke | 1323480, 1341539 |

127

## ABOUT HITRECORD

hitRECord is the open-collaborative production company founded and directed by actor and artist Joseph Gordon-Levitt. We create and develop art and media collectively using our website where anyone with an internet connection can upload their records, download and remix others' records, and work on projects together. When the results of our work and play are produced and make money, hitRECord splits the profits 50/50 with everybody who contributed to the final production.

Thanks again <3

### THE TINY BOOK OF TINY STORIES
volume 3

Original Concept & Creative Direction by wirrow
Directed by Joseph Gordon-Levitt
Produced by Jared Geller
Creative Direction, Layout & Design by Marke Johnson

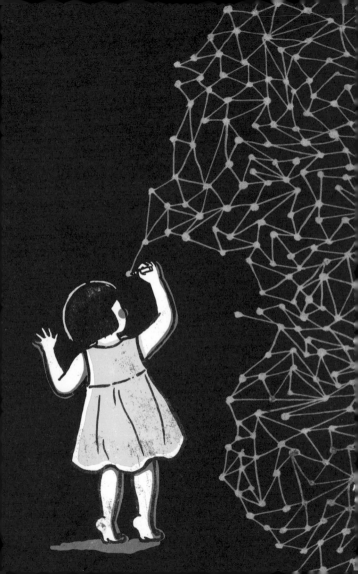